D0428586

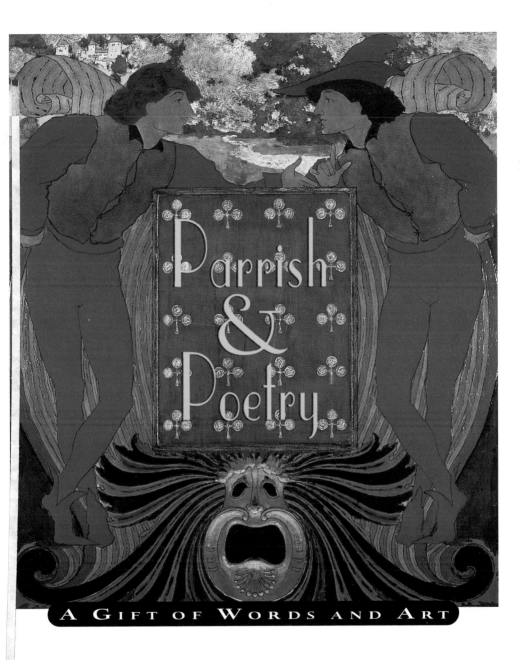

Parrish & Poetry

A GIFT OF WORDS AND ART

COMPILED AND EDITED BY
Laurence S. Cutler and Judy Goffman Cutler

POMEGRANATE ARTBOOKS ◆ SAN FRANCISCO

Published by
Pomegranate Artbooks
Box 6099
Rohnert Park, California 94927

Pomegranate Europe Ltd.
Fullbridge House, Fullbridge
Maldon, Essex CM9 7LE, England

© 1995 by Laurence S. Cutler, Judy Goffman Cutler, and the Maxfield Parrish Family
Trust™ of Holderness, New Hampshire
Photographs courtesy the Archives of the American Illustrators Gallery, New York City
Authorized by the Maxfield Parrish Family Trust

Title page illustration: Presentation design for bulletin board, Mask and Wig Club,
University of Pennsylvania, Philadelphia, 1895

All rights reserved.
No part of this book may be reproduced or transmitted in any form or by any means,
electronic or mechanical, including photocopying, recording, or by any information storage
and retrieval system, without permission in writing from the copyright holders.

Library of Congress Cataloging-in-Publication Data
Parrish, Maxfield, 1870–1966.
 Parrish & poetry : a gift of words and art / compiled and edited by
Laurence S. Cutler and Judy Goffman Cutler.
 p. cm.
 ISBN 0-87654-486-3
 1. Parrish, Maxfield, 1870–1966—Themes, motives. 2. Poetry,
Modern. I. Cutler, Laurence S. II. Cutler, Judy Goffman. III. Title.
ND237.P25213A4 1995
759.13—dc20 95-30368
 CIP

Pomegranate Catalog No. A821

Designed by Tim Lewis
Printed in Korea

00 99 98 97 96 95 6 5 4 3 2 1

FIRST EDITION

*To Lydia Parrish and Susan Lewin, the poetry of his life,
and to Beatrice and Doris, for the art is long and life is short.*

Contents

Preface 9

Introduction 10

Prologue to THE CANTERBURY TALES, Geoffrey Chaucer 14

 Photograph: Maxfield Parrish reading Chaucer *15*

EVEN SUCH IS TIME, Sir Walter Raleigh 16

 The Tempest *17*

THE PASSIONATE SHEPHERD TO HIS LOVE, Christopher Marlowe 18

 Shepherd with Purple Robe *19*

OH MISTRESS MINE, William Shakespeare 20

 Sleeping Beauty *21*

THE ECSTASY, John Donne 22

 Ecstasy *23*

STILL TO BE NEAT, Ben Jonson 24

 Lady Violetta about to Make the Tarts *25*

TO HIS COY MISTRESS, Andrew Marvell 26

 Griselda *27*

ODE ON SOLITUDE, Alexander Pope 28

 The Century *Midsummer Holiday Number* *29*

HOW SLEEP THE BRAVE, William Collins 30

 The Knave *31*

TO SPRING, William Blake 32

 Morning (Spring) *33*

THE BANKS O' DOON, Robert Burns 34

 Hilltop *35*

MUTABILITY, William Wordsworth 36

The Lute Players (Interlude) 37

SHE WALKS IN BEAUTY, George Gordon, Lord Byron 38

Florentine Fete: The Garden of Opportunity 39

WHEN WE TWO PARTED, George Gordon, Lord Byron 40

The Knave Watches Violetta Depart 41

PROMETHEUS UNBOUND (excerpt), Percy Bysshe Shelley 42

Prometheus 43

TO NIGHT, Percy Bysshe Shelley 44

Spirit of the Night 45

BRIGHT STAR, John Keats 46

Stars 47

I REMEMBER, I REMEMBER, Thomas Hood 48

Dream Light 49

WOODMAN, SPARE THAT TREE, George Pope Morris 50

Riverbank, Autumn 51

WATER, Ralph Waldo Emerson 52

Moonlight 53

HOW DO I LOVE THEE?, Elizabeth Barrett Browning 54

Deep Woods Moonlight 55

THE DAY IS DONE, Henry Wadsworth Longfellow 56

Deep Valley 57

THE VALLEY OF UNREST, Edgar Allan Poe 58

Sunlit Valley 59

THE SPLENDOR FALLS, Alfred, Lord Tennyson 60

Dream Castle in the Sky 61

FLOWER IN THE CRANNIED WALL, Alfred, Lord Tennyson 62

Sunrise 63

ROSES ON THE TERRACE, Alfred, Lord Tennyson 64

Florentine Fete: Buds below the Roses 65

THE LAST LEAF, Oliver Wendell Holmes 66

The Cardinal Archbishop *67*

TO THE MOUNTAINS, Henry David Thoreau 68

New Hampshire Hills *69*

FALL, LEAVES, FALL, Emily Brontë 70

River at Ascutney *71*

SUCCESS IS COUNTED SWEETEST, Emily Dickinson 72

Lady Ursula Kneeling before Pompdebile, King of Hearts *73*

REMEMBER, Christina Georgina Rossetti 74

Reveries *75*

OPPORTUNITY, John James Ingalls 76

Gateway of the Botanical Garden, Padua *77*

INVICTUS, William Ernest Henley 78

Dies Irae *79*

WYNKEN, BLYNKEN, AND NOD, Eugene Field 80

Wynken, Blynken, and Nod *81*

SOLITUDE, Ella Wheeler Wilcox 82

Solitude *83*

THE NIGHT HAS A THOUSAND EYES, Francis William Bourdillon 84

Enchantment *85*

OUTWITTED, Edwin Markham 86

Its Walls Were as of Jasper *87*

BLUE REMEMBERED HILLS, Alfred Edward Housman 88

Thy Rocks and Rills *89*

THE ANSWER, Rudyard Kipling 90

Garden of Allah *91*

WHEN I'M GONE TO COME NO MO', Georgia Sea Islands slave song 92

Photograph: Lydia Austin Parrish *93*

TREES, Joyce Kilmer 94

The Glen *95*

Preface

A t first glance, the title of this anthology may seem to imply that the poems contained herein were written by Maxfield Parrish (American, 1870–1966). This is not the case, as Parrish did not write poetry. He was an artist, an illustrator, a mechanic, an artisan, a carpenter, a raconteur, a celebrity, a father, and a grandfather, but not a poet with words. Parrish was a poet with paint.

Included in this volume are some of the most beloved and best-remembered poems of all times, arranged in roughly chronological order and each accompanied by a painting by Maxfield Parrish—hence the title *Parrish & Poetry*. Despite the pitfalls of potential misunderstanding, this simple alliterative title aptly describes this unique combination of masterpieces of literature and masterworks of painting—truly a gift of words and art.

Introduction

The poems and paintings in this volume have been selected and organized in an exacting manner. Not just another overwhelming compilation of golden oldies in a new anthology wrapper, this collection was painstakingly assembled according to specific artistic and personal criteria. Poems are included for one or more of the following reasons: (1) they were among Maxfield Parrish's favorites; (2) they evoke mental images similar to the visual images created by the artist; (3) they may have directly inspired Parrish's images, primarily because of their titles; (4) they conjure a Parrish-like ambiance of romance, fantasy, and inspiration; (5) they are considered great classics, lending themselves well to juxtapositioning with Parrish's classic works; (6) by virtue of either subject matter or wording, they simply seem to fit well. The poems run the broad gamut of a five-hundred-year span, beginning in the mid-fourteenth century and ending in the mid-twentieth century, yet each seems to reflect the style of this great artist and illustrator. In fact, Maxfield Parrish's tastes ranged all over the historical map, but they focused primarily on ancient Roman and classical Greek settings, architecture, and dress. In the final analysis, selection of these paintings and poems was guided by love for the image and the verse. However, a few comments regarding some of the pairings may shed further light on the selection process.

Both the first poem in this anthology and the last one were favorites of Maxfield Parrish. The first is, appropriately, the prologue to "The Canterbury Tales." We have always been struck by the fact that Parrish posed for one of his only known formal photographs with an illustrated book of Geoffrey Chaucer's works in his hands. This is particularly interesting because Parrish himself had illustrated so many books: one would have expected him to select

one of his own illustrated works for such a rare photographic portrait. This may, of course, have been merely an act of modesty on his part. Many have said that Parrish was extremely shy; indeed, he characterized himself as a "shrinking violet." The last poem in this volume, Joyce Kilmer's well-known poem "Trees," always caused Parrish to reflect on his landscape paintings. Oak trees were a major theme throughout his works; he even named his homestead in the Cornish, New Hampshire, art colony "The Oaks." Trees—their silhouetted forms, details of their leaves and bark, the filigree of their branches—intrigued Parrish as much as light intrigued the Impressionists. Parrish once revealed some of his Quaker upbringing (tempered by his own peculiar sense of humor) when he quipped, "'Only God can make a tree,' true enough, but I'd like to see Him paint one." In 1938, Parrish titled a calendar painting for the Thomas D. Murphy Company *Only God Can Make a Tree*.

Parrish designed sets for a 1909 production of William Shakespeare's *The Tempest*, and we have coupled one of these stage designs with Sir Walter Raleigh's poem "Even Such Is Time." We chose this combination, rather than the obvious matching of a specifically designed Parrish stage set with its Shakespearean counterpart, because the fit is better. Pairings like Shakespeare's "Oh Mistress Mine" with *Sleeping Beauty* and Ben Jonson's "Still to Be Neat" with *Lady Violetta about to Make the Tarts* also fall into this category.

Andrew Marvell's "To His Coy Mistress" is shown opposite the image of the Parrish favorite *Griselda*, posed for by Susan Lewin, Parrish's lifelong companion and model. Speculation and mystery have always surrounded this relationship, and one day it will be researched properly. Such speculation and mystery are always fun for romantics who read poetry and love beautiful pictures.

We could not dismiss the apparent relationships between Wil-

liam Blake's "To Spring" and Parrish's *Morning (Spring)*, John Keats's "Bright Star" and *Stars*, and Ella Wheeler Wilcox's "Solitude" and *Solitude* as coincidental or accidental. In these cases, we feel we may well have found the definitive inspirational sources for some of Parrish's art.

It is, of course, obligatory to match "Wynken, Blynken, and Nod" with its namesake, an illustration Parrish created for Eugene Field's *Poems of Childhood* (1904). *Poems of Childhood* was the first book Parrish illustrated in full color; its eight images include his well-loved paintings *The Dinkey-Bird* and *The Fly-Away Horse*. (L. Frank Baum's *Mother Goose in Prose* [1897], a prose version of the famed nursery rhymes coupled with Parrish illustrations, was actually the first book he illustrated.) Parrish would read Field's poems, become inspired, then interpret the words with his own images.

The only unattributed work contained herein is a slave song chronicled by Parrish's wife, Lydia Austin Parrish (1872–1953), "When I'm Gone to Come No Mo'." Lydia Parrish, a noted compiler of slave songs, published one of the first studies of American cultural anthropology, a compilation titled *Slave Songs of the Sea Islands of Georgia* (1942). This milestone work, a unique collection of African American songs that skillfully explores their tribal origins, documents African Americans' participation in the development of American civilization. The inclusion of this verse represents Mrs. Parrish's own immense contribution to the preservation of our collective American heritage.

As the reader well knows, a poem is a composition in verse that communicates a sense of a complete experience. Is this not what an illustration does for its viewer? Employing radiant use of color and applying the precepts of dynamic symmetry to structure an underlying harmonic balance, Maxfield Parrish created images

that evoke an utterly serene experience for his viewers. Look closely at these paintings: each scene conveys a particular emotion, either through the characters portrayed or through memories of some similarly sublime moment retrieved from one's own dusty cerebral archives.

Contemporary poems often leave the reader behind with their jarring cacophony or lack of metrical verse, and today's graphic images, paintings, and illustrations are often appreciated only because of someone else's recommendation or because they follow current trends in color, technique, materials, size, or subject matter. In contrast, this book, a marriage of noble words and noble images, was created for the enjoyment of those who treasure the artistry of classic poetry and paintings. We hope the reader will derive as much pleasure from this delightful collection as we do.

Laurence S. Cutler and Judy Goffman Cutler
Holderness, New Hampshire
July 1995

Prologue to The Canterbury Tales

GEOFFREY CHAUCER (C. 1342–1400)

When April with its sweet showers
Has pierced the drought of March to the root
And bathed every plant-vein in such liquid
As has the power to engender the flower;
When Zephyr also with its sweet breath
Has in every grove and field inspired
The tender crops, and the young sun
Has run half its course in Aries the Ram,
And small fowls make melody
That sleep all night with open eye
(Nature pierces them so in their hearts) —
Then people long to go on pilgrimages
And palmers to seek foreign shores
To distant shrines, known in sundry lands;
And especially from every shire's end
Of England they travel to Canterbury
To seek the holy blissful martyr
That has helped them when they were sick.
It happened that one day in that season
As I lay at the Tabard Inn in Southwark
Ready to travel on my pilgrimage
To Canterbury with a most devout heart,
There came at night into that lodging-place
Twenty-nine in a group
Of sundry people, by chance fallen
Into fellowship, and they were all pilgrims
Wanting to ride toward Canterbury.
The chambers and stables were roomy,
And we were very well accommodated.
Soon, when the sun had set,
I had spoken to every one of them
So that I was immediately in their fellowship.
And we agreed to get up early
To make our way to the place I have described to you.
Nonetheless, while I have some time and room
Before passing further into this tale,
It seems reasonable to me
To tell you the condition
Of each of them, as it seemed to me,
And what they were, and of what rank,
And also in what array they were.
I will first begin, then, with a knight. . . .

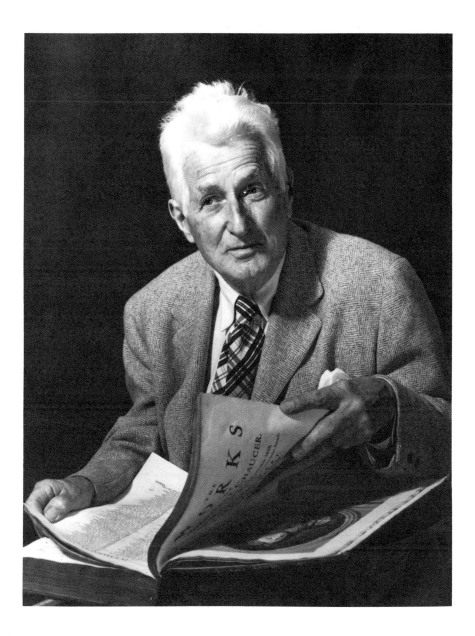

Maxfield Parrish at age eighty-six, reading Chaucer

Photograph by Aubrey Janion

Even Such Is Time

Sir Walter Raleigh (1554–1618)

Even such is time that takes in trust
Our youth, our joys, our all we have,
And pays us but with age and dust,
Who in the dark and silent grave,
When we have wandered all our ways,
Shuts up the story of our days.
But from this earth, this grave, this dust,
My God shall raise me up, I trust.

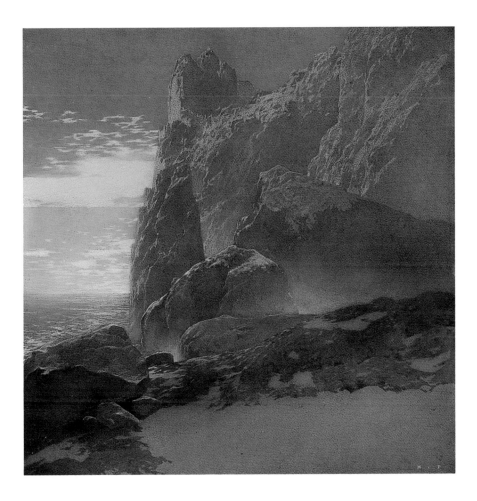

The Tempest, 1909

17

The Passionate Shepherd to His Love

CHRISTOPHER MARLOWE (1564–1593)

Come live with me and be my Love,
And we will all the pleasures prove
That valleys, groves, hills, and fields,
Woods, or steepy mountain yields.

And we will sit upon the rocks,
Seeing the shepherds feed their flocks
By shallow rivers, to whose falls
Melodious birds sing madrigals.

And I will make thee beds of roses
And a thousand fragrant posies;
A cap of flowers and a kirtle
Embroidered all with leaves of myrtle;

A gown made of the finest wool
Which from our pretty lambs we pull;
Fair-lined slippers for the cold,
With buckles of the purest gold;

A belt of straw and ivy buds,
With coral clasps and amber studs.
And if these pleasures may thee move,
Come live with me and be my Love.

The shepherd swains shall dance and sing
For thy delight each May morning.
If these delights thy mind may move,
Then live with me and be my Love.

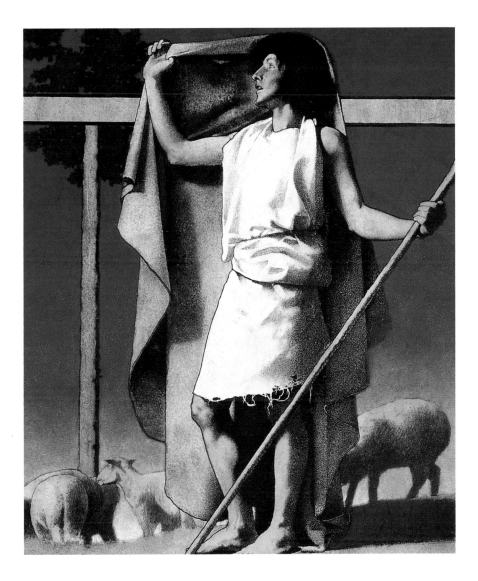

Shepherd with Purple Robe, 1889

Oh Mistress Mine

WILLIAM SHAKESPEARE (1564–1616)

Oh mistress mine! where are you roaming?
Oh! stay and hear; your true love's coming,
　　That can sing both high and low.
　　Trip no further, pretty sweeting;
　　Journeys end in lovers meeting,
　　Every wise man's son doth know.

　　What is love? 'tis not hereafter;
Present mirth hath present laughter;
　　What's to come is still unsure:
　　In delay there lies no plenty;
Then come kiss me, sweet and twenty,
　　Youth's a stuff will not endure.

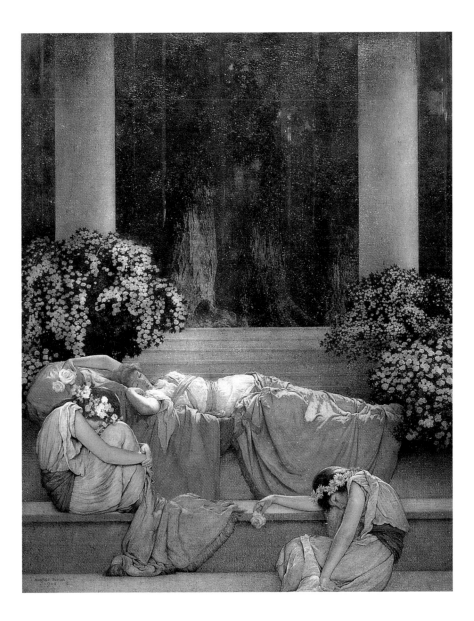

Sleeping Beauty, 1912

The Ecstasy

John Donne (1572–1631)

Where, like a pillow on a bed,
 A pregnant bank swelled up to rest
The violet's reclining head,
 Sat we two, one another's best.
Our hands were firmly cemented
 With a fast balm, which thence did spring;
Our eye-beams twisted, and did thread
 Our eyes, upon one double string;
So t'intergraft our hands, as yet
 Was all the means to make us one,
And pictures in our eyes to get
 Was all our propagation.
As 'twixt two equal armies, Fate
 Suspends uncertain victory,
Our souls, (which to advance their state
 Were gone out) hung 'twixt her and me.
And whilst our souls negotiate there,
 We like sepulchral statues lay;
All day, the same our postures were,
 And we said nothing, all the day.
If any, so by love refined
 That he soul's language understood,
He, (though he knew not which soul spake,
 Because both meant, both spake the same)
Might thence a new concoction take,
 And part far purer than he came.
"This ecstasy doth unperplex"
 (We said) "and tell us what we love.
We see by this, it was not sex;
 We see, we saw not what did move:
But as all several souls contain
 Mixtures of things, they know not what,
Love, these mixed souls doth mix again,
 And makes both one, each this and that.
A single violet transplant,
 The strength, the color, and the size,
(All which before was poor, and scant)

Redoubles still, and multiplies.
When love, with one another so
 Interanimates two souls,
That abler soul, which thence doth flow,
 Defect of loneliness controls.
We then, who are this new soul, know
 Of what we are composed, and made,
For, the atomies of which we grow,
 Are souls, whom no change can invade.
But oh, alas, so long, so far
 Our bodies why do we forbear?
They are ours, though they are not we; we are
 The intelligences, they the sphere.
We owe them thanks, because they thus,
 Did us, to us, at first convey,
Yielded their forces, sense, to us,
 Nor are dross to us, but allay.
On man heaven's influence works not so,
 But that it first imprints the air;
So soul into the soul may flow,
 Though it to body first repair.
As our blood labors to beget
 Spirits, as like souls as it can,
Because such fingers need to knit
 That subtle knot, which makes us man,
So must pure lovers' souls descend
 To affections and to faculties,
Which sense may reach and apprehend,
 Else a great prince in prison lies.
To our bodies turn we then, that so
 Weak men on love revealed may look;
Love's mysteries in souls do grow,
 But yet the body is his book.
And if some lover, such as we,
 Have heard this dialogue of one,
Let him still mark us; he shall see
 Small change, when we're to bodies gone."

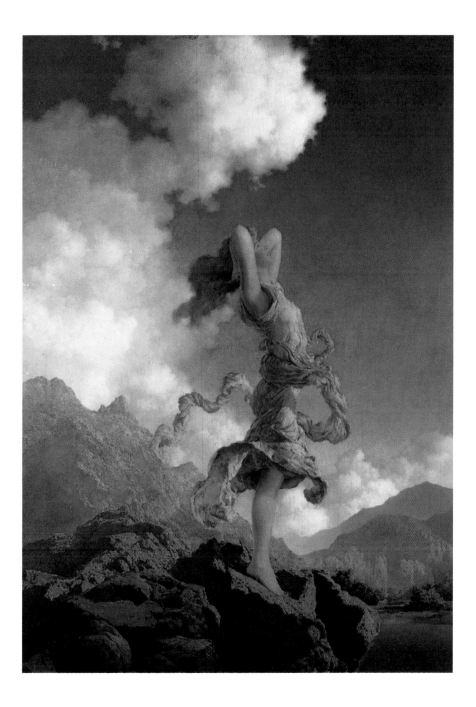

Ecstasy, 1929

Still to Be Neat

BEN JONSON (1572–1637)

Still to be neat, still to be dressed,
As you were going to a feast;
Still to be powdered, still perfumed:
Lady, it is to be presumed,
Though art's hid causes are not found,
All is not sweet, all is not sound.

Give me a look, give me a face,
That makes simplicity a grace;
Robes loosely flowing, hair is free:
Such sweet neglect more taketh me
Than all the adulteries of art;
They strike mine eyes, but not my heart.

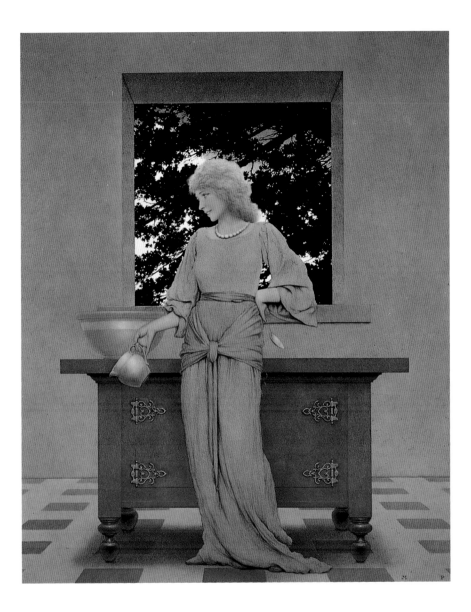

Lady Violetta about to Make the Tarts, 1921

To His Coy Mistress

ANDREW MARVELL (1621–1678)

Had we but world enough, and time,
This coyness, Lady, were no crime.
We would sit down and think which way
To walk and pass our long love's day,
Thou by the Indian Ganges' side
Shouldst rubies find; I by the tide
Of Humber would complain. I would
Love you ten years before the Flood;
And you should, if you please, refuse
Till the conversion of the Jews.
My vegetable love should grow
Vaster than empires, and more slow.
An hundred years should go to praise
Thine eyes and on thy forehead gaze;
Two hundred to adore each breast,
But thirty thousand to the rest;
An age at least to every part,
And the last age should show your heart.
For, Lady, you deserve this state,
Nor would I love at lower rate.
 But at my back I always hear
Time's wingèd chariot hurrying near;
And yonder all before us lie
Deserts of vast eternity.
Thy beauty shall no more be found,
Nor, in thy marble vault, shall sound
My echoing song; then worms shall try
That long preserved virginity,
And your quaint honor turn to dust,
And into ashes all my lust:
The grave's a fine and private place,
But none, I think, do there embrace.
 Now therefore, while the youthful hue
Sits on thy skin like morning dew,
And while thy willing soul transpires
At every pore with instant fires,
Now let us sport us while we may;
And now, like amorous birds of prey,
Rather at once our time devour
Than languish in his slow-chapped power.
Let us roll all our strength and all
Our sweetness up into one ball;
And tear our pleasures with rough strife
Through the iron gates of life:
Thus, though we cannot make our sun
Stand still, yet we will make him run.

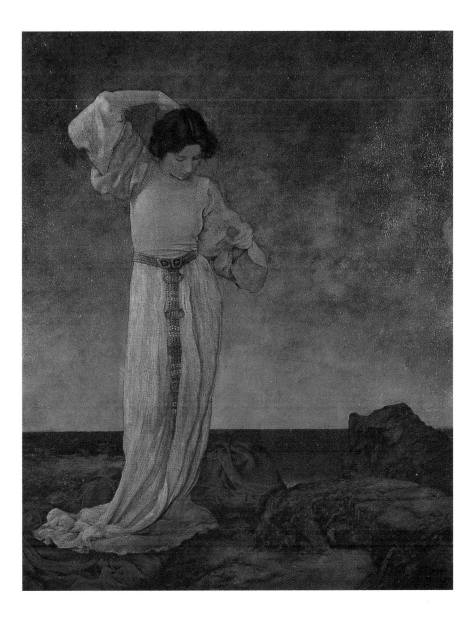

Griselda, 1910

Ode on Solitude

ALEXANDER POPE (1688–1892)

Happy the man whose wish and care
A few paternal acres bound,
Content to breathe his native air
In his own ground.

Whose herds with milk, whose fields with bread,
Whose flocks supply him with attire,
Whose trees in summer yield him shade,
In winter fire.

Blest, who can unconcernedly find
Hours, days, and years slide soft away,
In health of body, peace of mind,
Quiet by day,

Sound sleep by night; study and ease,
Together mixed; sweet recreation;
And innocence, which most does please
With meditation.

Thus let me live, unseen, unknown,
Thus unlamented let me die,
Steal from the world, and not a stone
Tell where I lie.

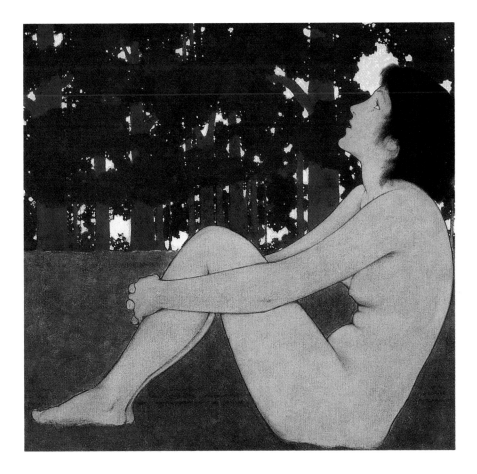

The Century *Midsummer Holiday Number,* August 1896

How Sleep the Brave

WILLIAM COLLINS (1721–1759)

How sleep the brave who sink to rest
By all their country's wishes blest!
When Spring, with dewy fingers cold,
Returns to deck their hallowed mold,
She there shall dress a sweeter sod
Than Fancy's feet have ever trod.

By fairy hands their knell is rung,
By forms unseen their dirge is sung;
There Honor comes, a pilgrim gray,
To bless the turf that wraps their clay,
And Freedom shall awhile repair,
To dwell a weeping hermit there!

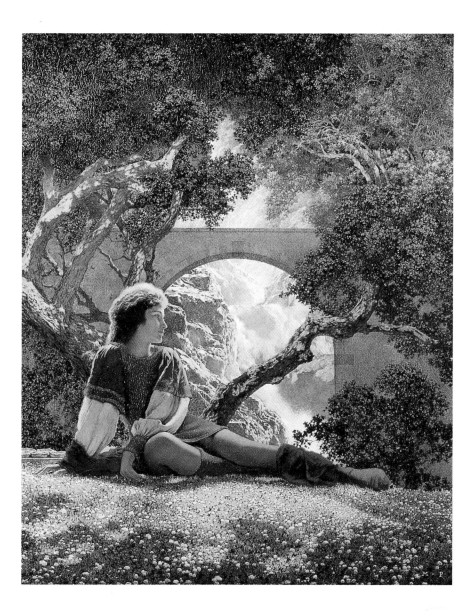

The Knave, 1925

To Spring

WILLIAM BLAKE (1757–1827)

O thou with dewy locks, who lookest down
Thro' the clear windows of the morning, turn
Thine angel eyes upon our western isle,
Which in full choir hails thy approach, O Spring!

The hills tell each other, and the list'ning
Vallies hear; all our longing eyes are turned
Up to thy bright pavillions; issue forth,
And let thy holy feet visit our clime.

Come o'er the eastern hills, and let our winds
Kiss thy perfumed garments; let us taste
Thy morn and evening breath; scatter thy pearls
Upon our love-sick land that mourns for thee.

O deck her forth with thy fair fingers; pour
Thy soft kisses on her bosom; and put
Thy golden crown upon her languish'd head,
Whose modest tresses were bound up for thee!

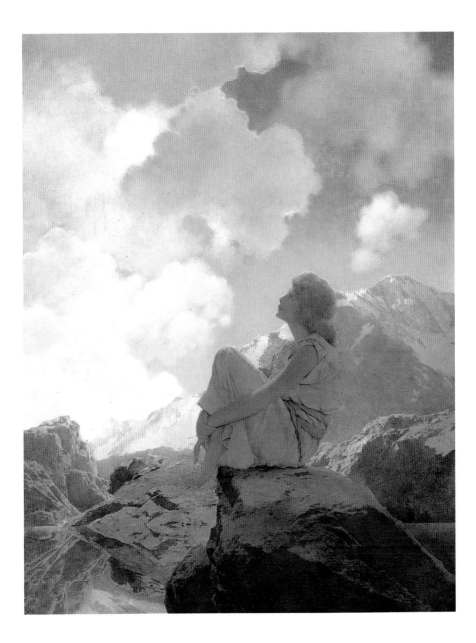

Morning (Spring), 1922

The Banks o' Doon

ROBERT BURNS (1759–1796)

Ye flowery banks o' bonnie Doon,
How can ye blume sae fair!
How can ye chant, ye little birds,
And I sae fu' o' care!

Thou'll break my heart, thou bonnie bird
That sings upon the bough;
Thou minds me o' the happy days
When my fause Luve was true.

Thou'll break my heart, thou bonnie bird
That sings beside thy mate;
For sae I sat, and sae I sang,
And wist na o' my fate.

Aft hae I roved by bonnie Doon
To see the woodbine twine,
And ilka bird sang o' its love;
And sae did I o' mine.

Wi' lightsome heart I pu'd a rose,
Frae aff its thorny tree;
And my fause luver staw the rose,
But left the thorn wi' me.

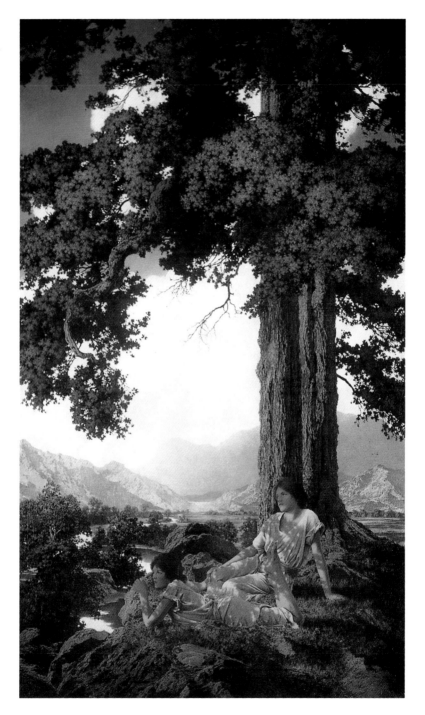

Hilltop, 1926

Mutability

WILLIAM WORDSWORTH (1770–1850)

From low to high doth dissolution climb,
And sink from high to low, along a scale
Of awful notes, whose concord shall not fail;
A musical but melancholy chime,
Which they can hear who meddle not with crime,
Nor avarice, nor over-anxious care.
Truth fails not; but her outward forms that bear
The longest date do melt like frosty rime,
That in the morning whitened hill and plain
And is no more; drop like the tower sublime
Of yesterday, which royally did wear
His crown of weeds, but could not even sustain
Some casual shout that broke the silent air,
Or the unimaginable touch of Time.

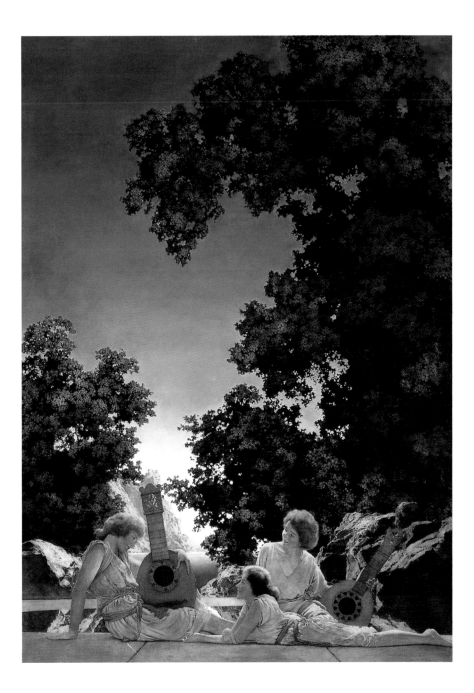

The Lute Players (Interlude), 1922

She Walks in Beauty

George Gordon, Lord Byron (1788–1824)

She walks in beauty, like the night
Of cloudless climes and starry skies;
And all that's best of dark and bright
Meet in her aspect and her eyes:
Thus mellow'd to that tender light
Which heaven to gaudy day denies.

One shade the more, one ray the less,
Had half impair'd the nameless grace
Which waves in every raven tress,
Or softly lightens o'er her face;
Where thoughts serenely sweet express
How pure, how dear their dwelling-place.

And on that cheek, and o'er that brow,
So soft, so calm, yet eloquent,
The smiles that win, the tints that glow,
But tell of days in goodness spent,
A mind at peace with all below,
A heart whose love is innocent!

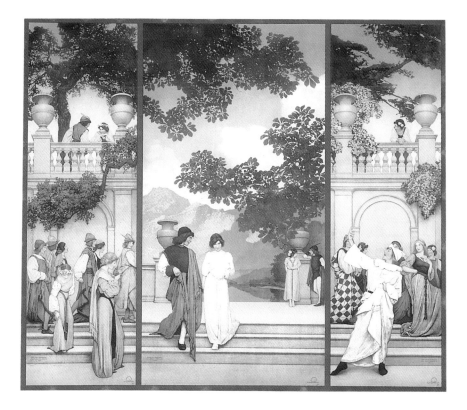

Florentine Fete: The Garden of Opportunity, 1913

When We Two Parted

George Gordon, Lord Byron (1788–1824)

When we two parted
In silence and tears,
Half broken-hearted
To sever for years,
Pale grew thy cheek and cold,
Colder thy kiss;
Truly that hour foretold
Sorrow to this.

The dew of the morning
Sunk chill on my brow—
It felt like the warning
Of what I feel now.
Thy vows are all broken,
And light is thy fame;
I hear thy name spoken,
And share in its shame.

They name thee before me,
A knell to mine ear;
A shudder comes o'er me—
Why wert thou so dear?
They know not I knew thee,
Who knew thee too well:—
Long, long shall I rue thee,
Too deeply to tell.

In secret we met—
In silence I grieve,
That thy heart could forget,
Thy spirit deceive.
If I should meet thee
After long years,
How should I greet thee?
With silence and tears.

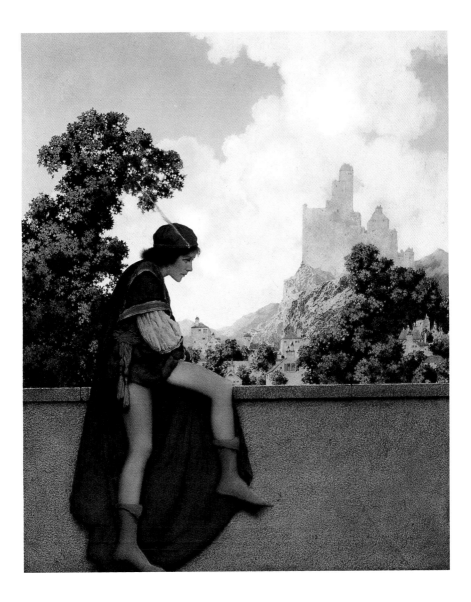

The Knave Watches Violetta Depart, 1924

Excerpt from Prometheus Unbound

PERCY BYSSHE SHELLEY (1792–1822)

Life of Life! thy lips enkindle
With their love the breath between them;
And thy smiles before they dwindle
Make the cold air fire; then screen them
In those looks, where whoso gazes
Faints, entangled in their mazes.
Child of Light! thy limbs are burning
Through the vest which seems to hide them;
As the radiant lines of morning
Through the clouds ere they divide them;
And this atmosphere divinest
Shrouds thee wheresoe'er thou shinest.

Fair are others; none beholds thee,
But thy voice sounds low and tender
Like the fairest, for it folds thee
From the sight, that liquid splendour,
And all feel, yet see thee never,
As I feel now, lost for ever!

Lamp of Earth! where'er thou movest
Its dim shapes are clad with brightness,
And the souls of whom thou lovest
Walk upon the winds with lightness,
Till they fail, as I am failing,
Dizzy, lost, yet unbewailing!

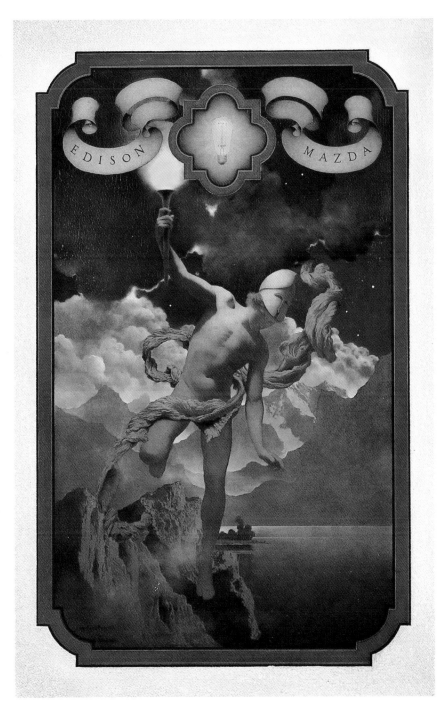

Prometheus, 1919

To Night

PERCY BYSSHE SHELLEY (1792–1822)

Swiftly walk o'er the western wave,
Spirit of Night!
Out of the misty eastern cave,
Where, all the long and lone daylight,
Thou wovest dreams of joy and fear,
Which make thee terrible and dear,
Swift by thy flight!

Wrap thy form in a mantle gray,
Star-inwrought!
Blind with thine hair the eyes of day;
Kiss her until she be wearied out,
Then wander o'er city, and sea, and land,
Touching all with thine opiate wand—
Come, long-sought!

When I arose and saw the dawn,
I sighed for thee;
When light rode high, and the dew was gone,
And noon lay heavy on flower and tree,
And the weary Day turned to his rest,
Lingering like an unloved guest,
I sighed for thee.

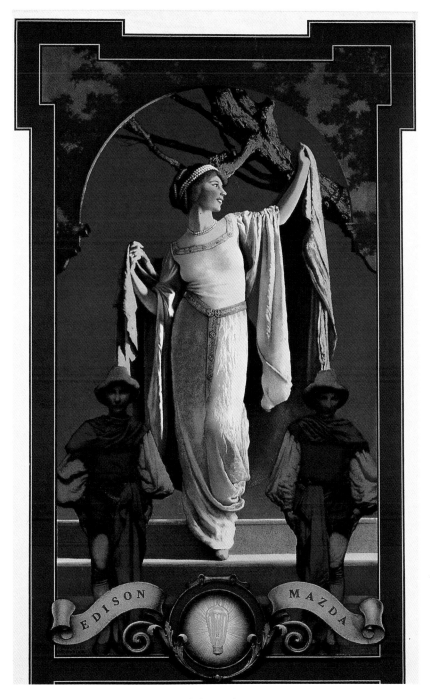

Spirit of the Night, 1919

Bright Star

JOHN KEATS (1795–1821)

Bright star, would I were steadfast as thou art—
 Not in lone splendor hung aloft the night,
 And watching, with eternal lids apart,
 Like nature's patient sleepless Eremite,
The moving waters at their priestlike task
Of pure ablution round earth's human shores,
 Or gazing on the new soft fallen mask
Of snow upon the mountains and the moors:
No—yet still steadfast, still unchangeable,
Pillowed upon my fair love's ripening breast
 To feel for ever its soft fall and swell,
 Awake for ever in a sweet unrest;
 Still, still to hear her tender-taken breath,
And so live ever—or else swoon to death.

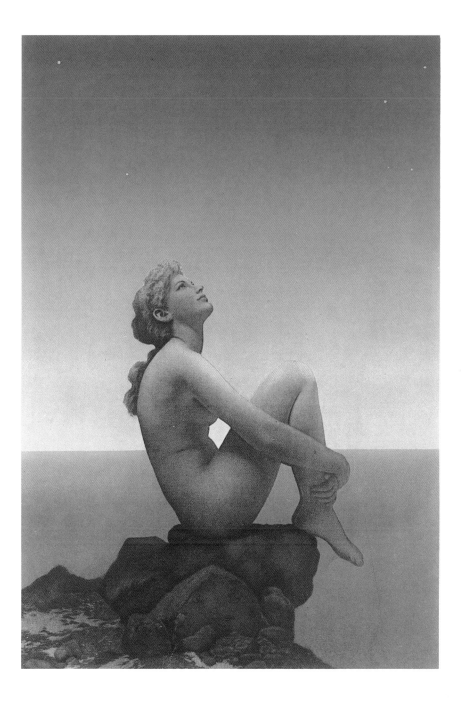

Stars, 1926

I Remember, I Remember

Thomas Hood (1799–1845)

I remember, I remember,
The house where I was born,
The little window where the sun
Came peeping in at morn:
He never came a wink too soon,
Nor brought too long a day;
But now, I often wish the night
Had borne my breath away.

I remember, I remember,
The roses, red and white;
The violets and the lily-cups,
Those flowers made of light!
The lilacs where the robin built,
And where my brother set
The laburnum on his birthday,—
The tree is living yet!

I remember, I remember,
Where I was used to swing;
And thought the air must rush as fresh
To swallows on the wing:
My spirit flew in feathers then,
That is so heavy now,
And summer pools could hardly cool
The fever on my brow!

I remember, I remember,
The fir trees dark and high;
I used to think their slender tops
Were close against the sky:
It was a childish ignorance,
But now 'tis little joy
To know I'm farther off from heaven
Than when I was a boy.

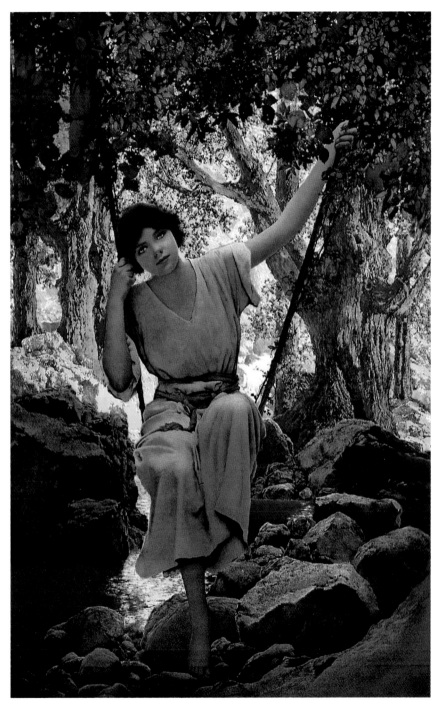

Dream Light, 1925

Woodman, Spare That Tree

GEORGE POPE MORRIS (1802–1864)

Woodman, spare that tree!
Touch not a single bough!
In youth it sheltered me,
And I'll protect it now.

'Twas my forefather's hand
That placed it near his cot;
There, woodman, let it stand,
Thy ax shall harm it not!

That old familiar tree,
Whose glory and renown
Are spread o'er land and sea,
And wouldst thou hew it down?

Woodman, forbear thy stroke!
Cut not its earth-bound ties!
Oh! spare that aged oak,
Now towering to the skies.

When but an idle boy
I sought its grateful shade;
In all their gushing joy
Here too my sisters played.

My mother kissed me here
My father pressed my hand—
Forgive this foolish tear,
But let that old oak stand!

My heart-strings round thee cling,
Close as thy bark, old friend!
Here shall the wild-bird sing,
And still thy branches bend.

Old tree, the storm still brave!
And, woodman, leave the spot!
While I've a hand to save,
Thy ax shall harm it not.

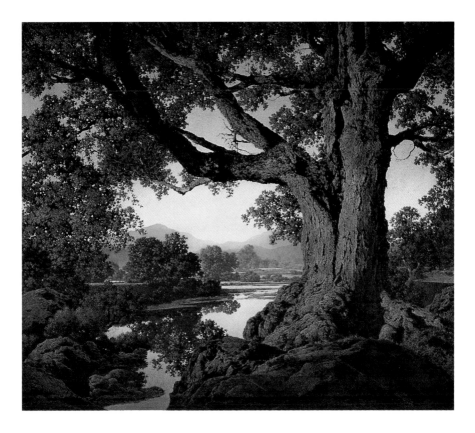

Riverbank, Autumn, 1938

Water

RALPH WALDO EMERSON (1803–1882)

The water understands
Civilization well;
It wets my foot, but prettily,
It chills my life, but wittily,
It is not disconcerted,
It is not broken-hearted:
Well used, it decketh joy,
Adorneth, doubleth joy:
Ill used, it will destroy,
With a face of golden pleasure
Elegantly destroy.

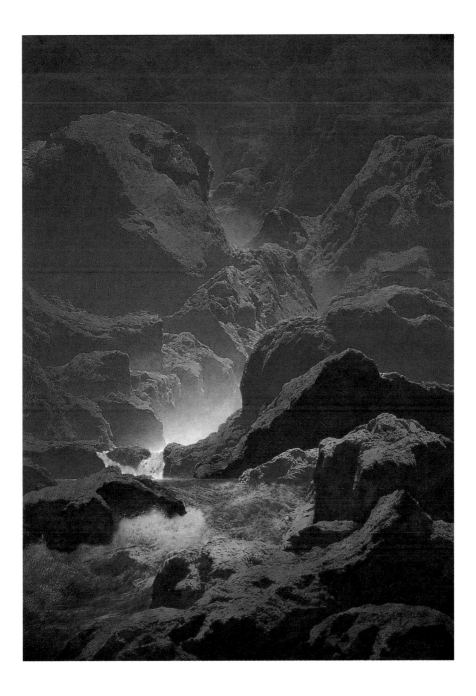

Moonlight, 1932

How Do I Love Thee?

ELIZABETH BARRETT BROWNING (1806–1861)

How do I love thee? Let me count the ways.
I love thee to the depth and breadth and height
My soul can reach, when feeling out of sight
For the Ends of Being and ideal Grace.
I love thee to the level of every day's
Most quiet need, by sun and candle-light.
I love thee freely, as men strive for Right;
I love thee purely, as they turn from Praise.
I love thee with the passion put to use
In my old griefs, and with my childhood's faith.
I love thee with a love I seemed to lose
With my lost saints—I love thee with the breath,
Smiles, tears, of all my life!—and, if God choose,
I shall but love thee better after death.

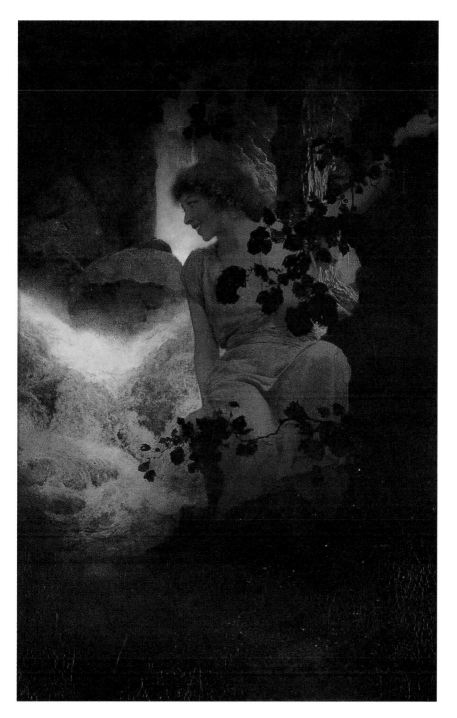

Deep Woods Moonlight, 1916

The Day Is Done

HENRY WADSWORTH LONGFELLOW (1807–1882)

The day is done, and the darkness
Falls from the wings of Night,
As a feather is wafted downward
From an eagle in his flight.

I see the lights of the village
Gleam through the rain and the mist,
And a feeling of sadness comes o'er me
That my soul cannot resist:

A feeling of sadness and longing,
That is not akin to pain,
And resembles sorrow only
As the mist resembles the rain.

Come, read to me some poem,
Some simple and heartfelt lay,
That shall soothe this restless feeling,
And banish the thoughts of day.

Not from the grand old masters,
Not from the bards sublime,
Whose distant footsteps echo
Through the corridors of time.

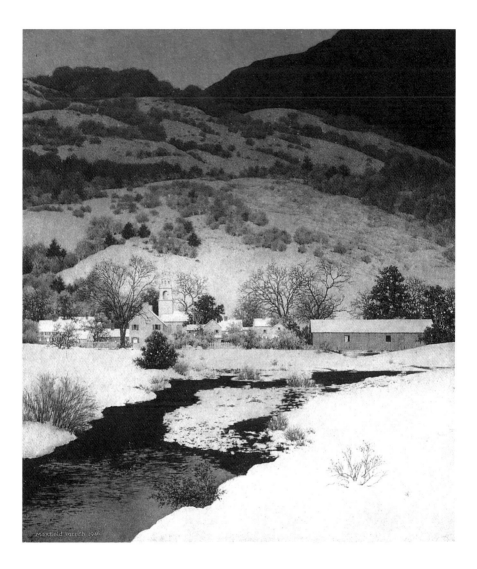

Deep Valley, 1946

The Valley of Unrest

EDGAR ALLAN POE (1809–1849)

Once it smiled a silent dell
Where people did not dwell;
They had gone unto the wars,
Trusting to the mild-eyed stars,
Nightly, from their azure towers,
To keep watch above the flowers,
In the midst of which all day
The red sun-light lazily lay.
Now each visitor shall confess
The sad valley's restlessness.
Nothing there is motionless—
Nothing save the airs that brood
Over the magic solitude.
Ah, by no wind are stirred those trees
That palpitate like the chill seas
Around the misty Hebrides!
Ah, by no wind those clouds are driven
That rustle through the unquiet Heaven
Uneasily, from morn till even,
Over the violets there that lie
In myriad types of the human eye—
Over the lilies there that wave
And weep above a nameless grave!
They wave: —from out their fragrant tops
Eternal dews come down in drops.
They weep: —from off their delicate stems
Perennial tears descend in gems.

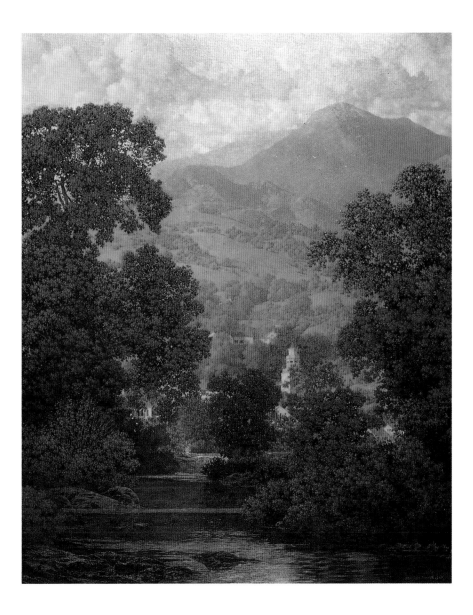

Sunlit Valley, 1947

59

The Splendor Falls

ALFRED, LORD TENNYSON (1809–1892)

The splendor falls on castle walls
And snowy summits old in story;
The long light shakes across the lakes,
And the wild cataract leaps in glory.
Blow, bugle, blow, set the wild echoes flying,
Blow, bugle; answer, echoes, dying, dying, dying.

O, hark, O, hear! how thin and clear,
And thinner, clearer, farther going!
O, sweet and far from cliff and scar
The horns of Elfland faintly blowing!
Blow, let us hear the purple glens replying,
Blow, bugle; answer, echoes, dying, dying, dying.

O love, they die in yon rich sky,
They faint on hill or field or river;
Our echoes roll from soul to soul,
And grow for ever and for ever.
Blow, bugle, blow, set the wild echoes flying,
And answer, echoes, answer, dying, dying, dying.

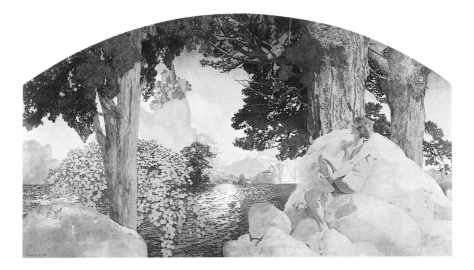

Dream Castle in the Sky, 1908

Flower in the Crannied Wall

ALFRED, LORD TENNYSON (1809–1892)

Flower in the crannied wall,
I pluck you out of the crannies,
I hold you here, root and all, in my hand,
Little flower—but *if* I could understand
What you are, root and all, and all in all,
I should know what God and man is.

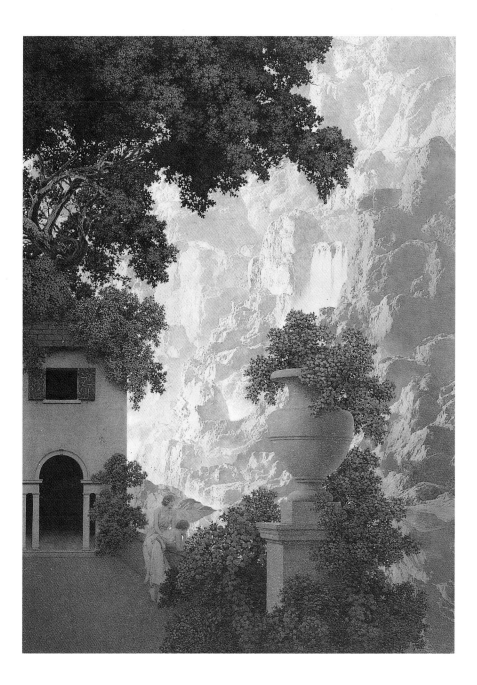

Sunrise, 1931

Roses on the Terrace

ALFRED, LORD TENNYSON (1809–1892)

Rose, on this terrace fifty years ago,
When I was in my June, you in your May,
Two words, "My Rose," set all your face aglow,
And now that I am white, and you are gray,
That blush of fifty years ago, my dear,
Blooms in the Past, but close to me today
As this red rose, which on our terrace here
Glows in the blue of fifty miles away.

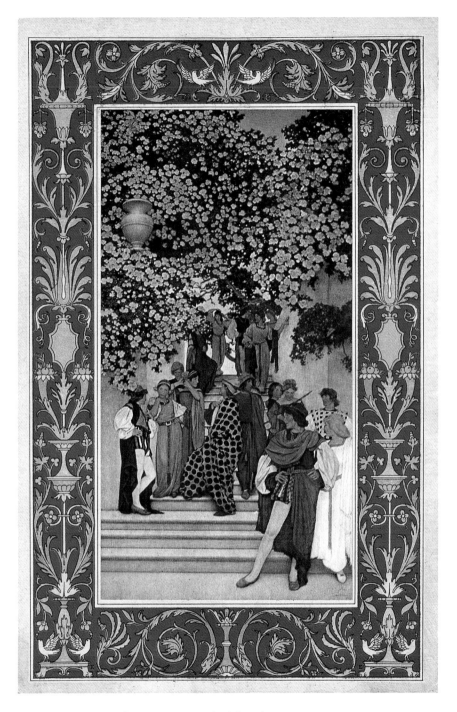

Florentine Fete: Buds below the Roses, 1912

The Last Leaf

OLIVER WENDELL HOLMES (1809–1894)

I saw him once before,
As he passed by the door,
And again
The pavement stones resound,
As he totters o'er the ground
With his cane.

They say that in his prime,
Ere the pruning-knife of Time
Cut him down,
Not a better man was found
By the Crier on his round
Through the town.

But now he walks the streets,
And he looks at all he meets
Sad and wan,
And he shakes his feeble head,
That it seems as if he said,
"They are gone."

The mossy marbles rest
On the lips that he has prest
In their bloom,
And the names he loved to hear
Have been carved for many a year
On the tomb.

My grandmamma has said—
Poor old lady, she is dead
Long ago—
That he had a Roman nose,
And his cheek was like a rose
In the snow;

But now his nose is thin,
And it rests upon his chin
Like a staff,
And a crook is in his back,
And a melancholy crack
In his laugh.

I know it is a sin
For me to sit and grin
At him here;
But the old three-cornered hat,
And the breeches, and all that,
Are so queer!

And if I should live to be
The last leaf upon the tree
In the spring,
Let them smile, as I do now,
At the old forsaken bough
Where I cling.

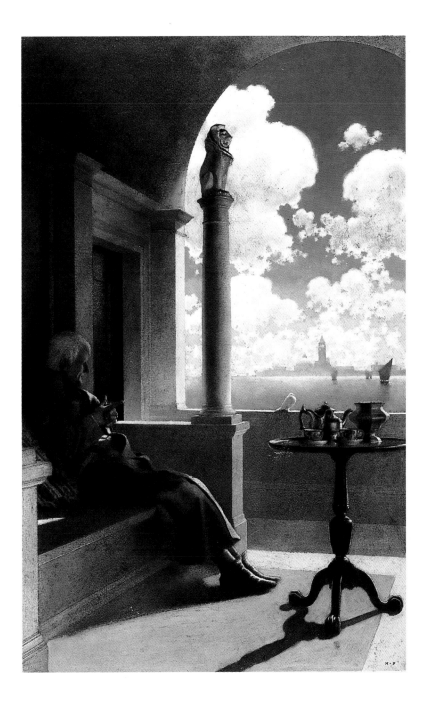

The Cardinal Archbishop, 1901

To the Mountains

HENRY DAVID THOREAU (1817–1862)

And when the sun puts out his lamp
We'll sleep serene within the camp,
Trusting to his invet'rate skill
Who leads the stars o'er yonder hill,
Whose discipline doth never cease
To watch the slumberings of peace,
And from the virtuous hold afar
The melancholy din of war.—
For ye our sentries still outlie,
The earth your pallet and your screen the sky.

From steadfastness I will not swerve,
Remembering my sweet reserve.

With all your kindness shown from year to year
Ye do but civil demons still appear;
Still to my mind
Ye are inhuman and unkind,
And bear an untamed aspect to my sight
After the "civil-suited" night,
As if ye had lain out
Like to the Indian scout
Who lingers in the purlieus of the towns
With unexplored grace and savage frowns.

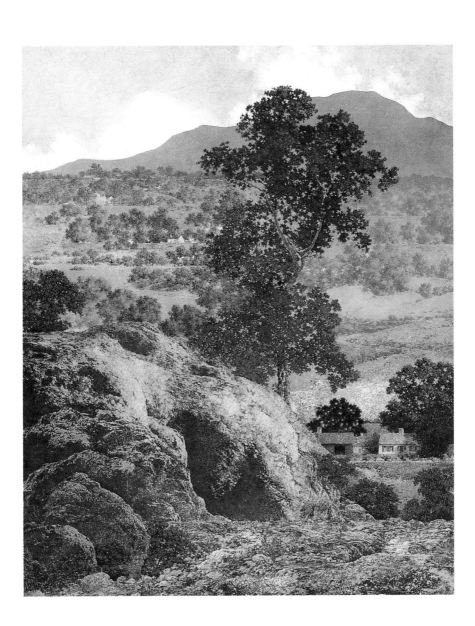

New Hampshire Hills, 1932

Fall, Leaves, Fall

EMILY BRONTË (1818–1848)

Fall, leaves, fall; die, flowers, away;
Lengthen night and shorten day;
Every leaf speaks bliss to me,
Fluttering from the autumn tree.
I shall smile when wreaths of snow
Blossom where the rose should grow;
I shall sing when night's decay
Ushers in a drearier day.

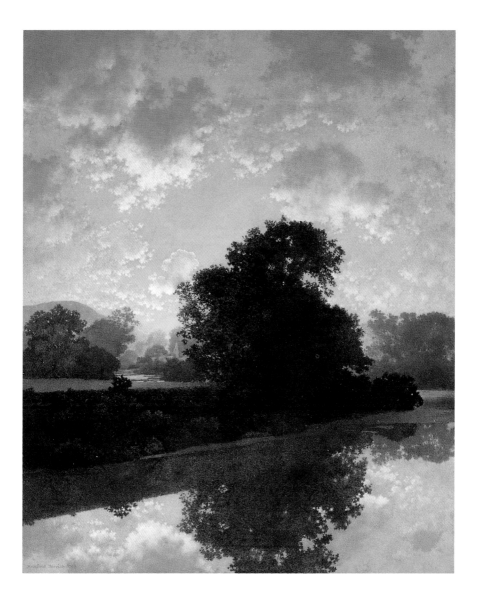

River at Ascutney, 1941

Success Is Counted Sweetest

EMILY DICKINSON (1830–1886)

Success is counted sweetest
By those who ne'er succeed.
To comprehend a nectar
Requires sorest need.

Not one of all the purple Host
Who took the Flag today
Can tell the definition
So clear of Victory

As he defeated—dying—
On whose forbidden ear
The distant strains of triumph
Burst agonized and clear!

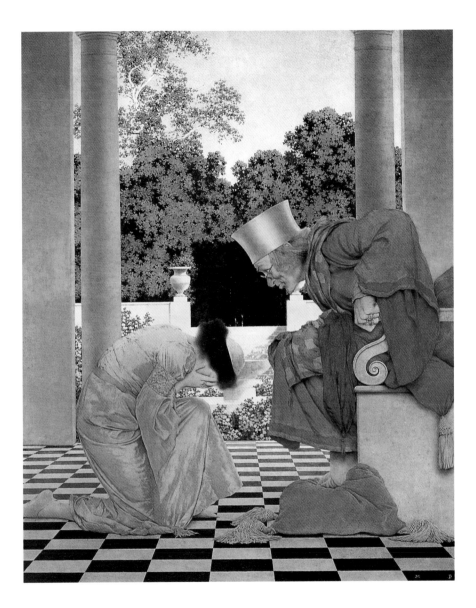

Lady Ursula Kneeling before Pompdebile, King of Hearts, 1924

73

Remember

CHRISTINA GEORGINA ROSSETTI (1830–1894)

Remember me when I am gone away,
Gone far away into the silent land;
When you can no more hold me by the hand,
Nor I half turn to go yet turning to stay.
Remember me when no more day by day
You tell me of our future that you planned:
Only remember me; you understand
It will be late to counsel then or pray.
Yet if you should forget me for a while
And afterwards remember, do not grieve:
For if the darkness and corruption leave
A vestige of the thoughts that once I had,
Better by far you should forget and smile
Than that you should remember and be sad.

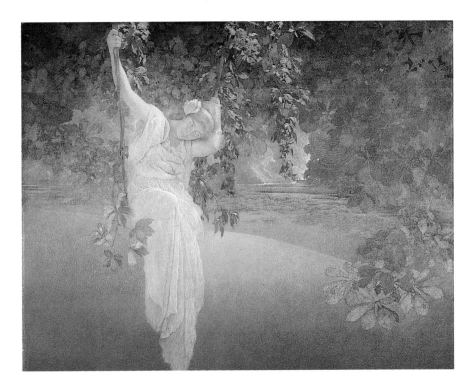

Reveries, 1913

Opportunity

JOHN JAMES INGALLS (1833–1900)

Master of human destinies am I.
Fame, love, and fortune on my footsteps wait,
Cities and fields I walk; I penetrate
Deserts and seas remote, and, passing by
Hovel, and mart, and palace, soon or late
I knock unbidden, once at every gate!
If sleeping, wake—if feasting, rise before
I turn away. It is the hour of fate,
And they who follow me reach every state
Mortals desire, and conquer every foe
Save death; but those who doubt or hesitate,
Condemned to failure, penury and woe,
Seek me in vain and uselessly implore—
I answer not, and I return no more.

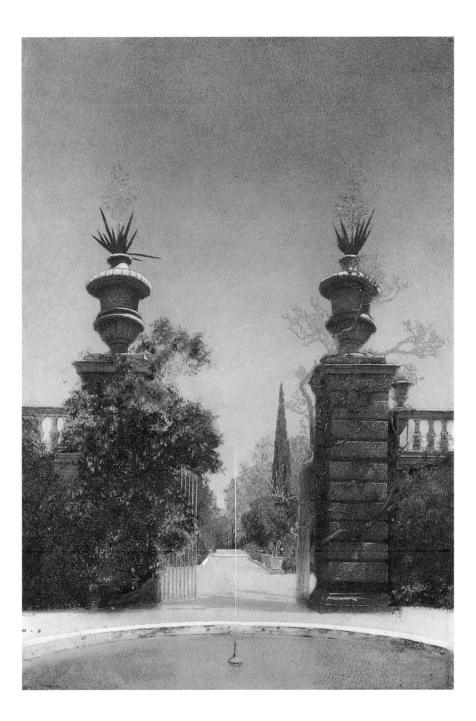

Gateway of the Botanical Garden, Padua, 1904

Invictus

WILLIAM ERNEST HENLEY (1849–1903)

Out of the night that covers me,
Black as the Pit from pole to pole,
I thank whatever gods may be
For my unconquerable soul.

In the fell clutch of circumstance,
I have not winced nor cried aloud;
Under the bludgeonings of chance
My head is bloody, but unbow'd.

Beyond this place of wrath and tears
Looms but the Horror of the shade,
And yet the menace of the years
Finds and shall find me unafraid.

It matters not how strait the gate,
How charged with punishments the scroll,
I am the master of my fate;
I am the captain of my soul.

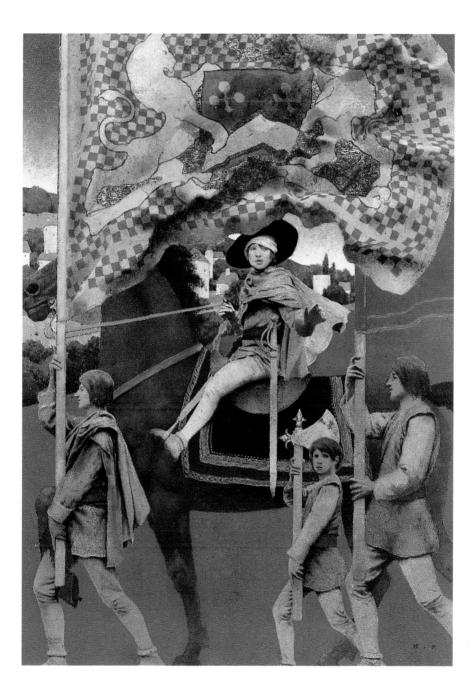

Dies Irae, 1902

Wynken, Blynken, and Nod

Eugene Field (1850–1895)

Wynken, Blynken, and Nod one night
Sailed off in a wooden shoe,—
Sailed on a river of misty light
Into a sea of dew.
"Where are you going, and what do you wish?"
The old moon asked the three.
"We have come to fish for the herring-fish
That live in this beautiful sea;
Nets of silver and gold have we,"
Said Wynken, Blynken, and Nod.

The old moon laughed and sang a song,
As they rocked in the wooden shoe;
And the wind that sped them all night long
Ruffled the waves of dew;
The little stars were the herring-fish
That lived in the beautiful sea.
"Now cast your nets wherever you wish,—
But never afeared are we!"
So cried the stars to the fishermen three,
Wynken, Blynken, and Nod.

All night long their nets they threw
For the stars in the twinkling foam,—
Then down from the sky came the wooden shoe,
Bringing the fishermen home:
'Twas all so pretty a sail, it seemed
As if it could not be;
And some folk thought 'twas a dream they'd dreamed
Of sailing that beautiful sea;
But I shall name you fishermen three:
Wynken, Blynken, and Nod.

Wynken and Blynken are two little eyes,
And Nod is a little head,
And the wooden shoe that sailed the skies
Is a wee one's trundle-bed;
So shut your eyes while Mother sings
Of wonderful sights that be,
And you shall see the beautiful things
As you rock on the misty sea
Where the old shoe rocked the fishermen three,—
Wynken, Blynken, and Nod.

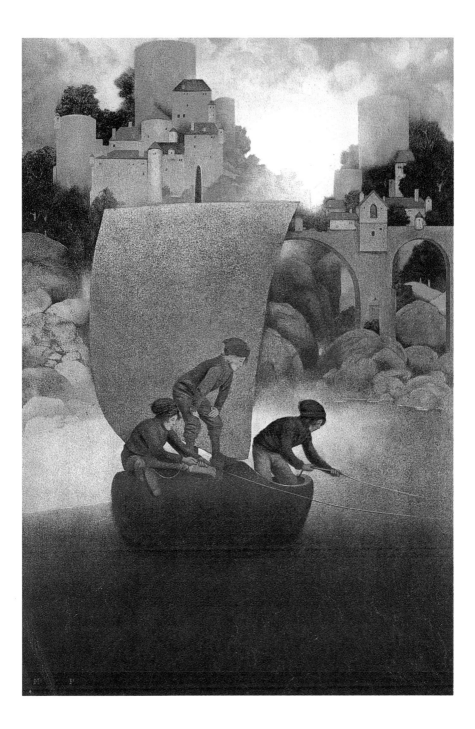

Wynken, Blynken, and Nod, 1903

Solitude

ELLA WHEELER WILCOX (1850–1919)

Laugh, and the world laughs with you;
Weep, and you weep alone.
For the sad old earth must borrow its mirth,
But has trouble enough of its own.
Sing, and the hills will answer;
Sigh, it is lost on the air.
The echoes bound to a joyful sound,
But shrink from voicing care.

Rejoice, and men will seek you;
Grieve, and they turn and go.
They want full measure of all your pleasure,
But they do not need your woe.
Be glad, and your friends are many;
Be sad, and you lose them all.
There are none to decline your nectared wine,
But alone you must drink life's gall.

Feast, and your halls are crowded;
Fast, and the world goes by.
Succeed and give, and it helps you live,
But no man can help you die.
There is room in the halls of pleasure
For a long and lordly train,
But one by one we must all file on
Through the narrow aisles of pain.

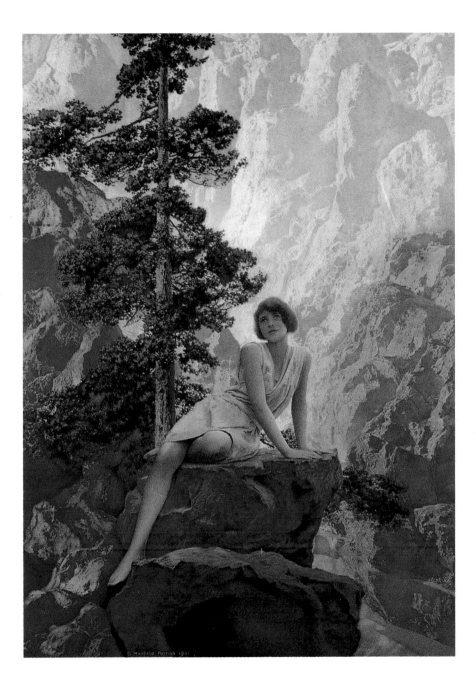

Solitude, 1932

The Night Has a Thousand Eyes

Francis William Bourdillon (1852–1921)

The night has a thousand eyes,
And the day but one;
Yet the light of the bright world dies
With the dying sun.

The mind has a thousand eyes,
And the heart but one;
Yet the light of a whole life dies
When love is done.

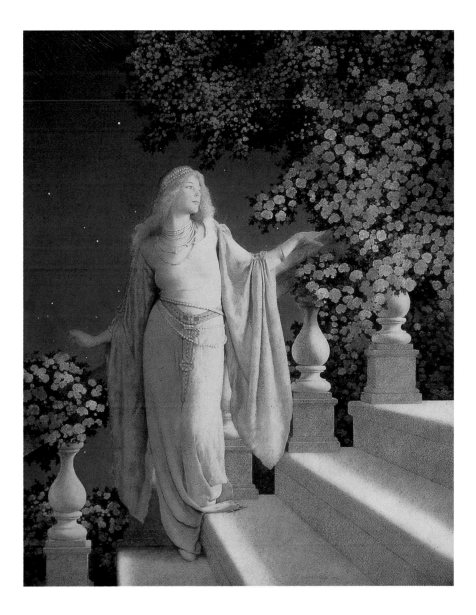

Enchantment, 1913

Outwitted

EDWIN MARKHAM (1852–1940)

He drew a circle that shut me out—
Heretic, rebel, a thing to flout.
But Love and I had the wit to win:
We drew a circle that took him in!

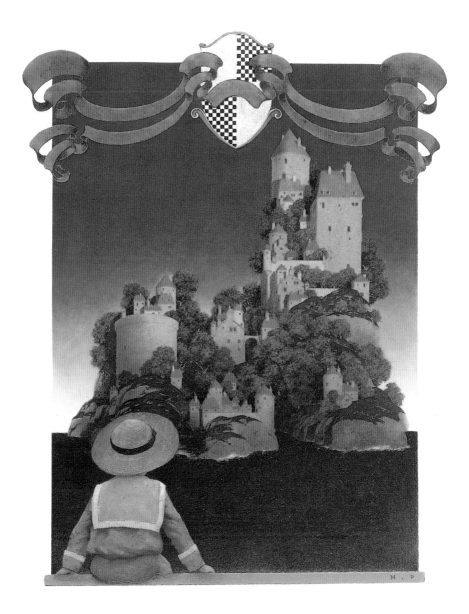

Its Walls Were as of Jasper, 1900

Blue Remembered Hills
(Into My Heart an Air That Kills)

ALFRED EDWARD HOUSMAN (1859–1936)

Into my heart an air that kills
From yon far country blows:
What are those blue remembered hills,
What spires, what farms are those?

That is the land of lost content,
I see it shining plain,
The happy highways where I went
And cannot come again.

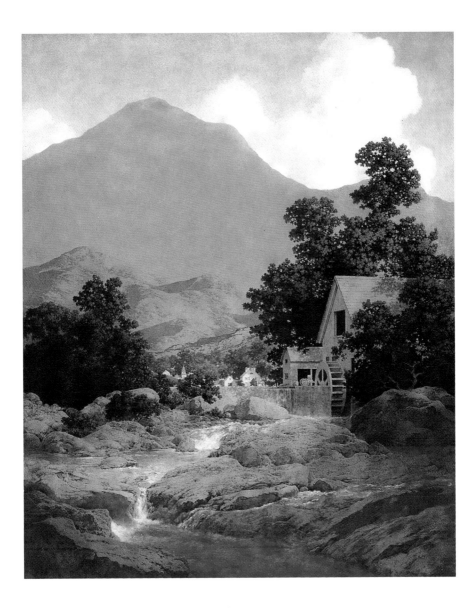

Thy Rocks and Rills, 1942

The Answer

RUDYARD KIPLING (1865–1936)

A Rose, in tatters on the garden path,
Cried out to God and murmured 'gainst His wrath,
Because a sudden wind at twilight's hush
Had snapped her stem alone of all the bush.
And God, Who hears both sun-dried dust and sun,
Had pity, whispering to that luckless one.
"Sister, in that thou sayest We did not well—
What voices heardst thou when thy petals fell?"
And the Rose answered, "In that evil hour
A voice said, 'Father wherefore falls the flower?
For lo, the very gossamers are still.'
And a voice answered, 'Son, by Allah's Will!'"

Then softly as a rain-mist on the sward,
Came to the Rose the answer of the Lord:
"Sister, before We smote the dark in twain,
Ere yet the stars saw one another plain,
Time, tide, and space, We bound unto the task
That thou shouldst fall, and such an one should ask."
Whereat the withered flower, all content,
Died as they die whose days are innocent;
While he who questioned why the flower fell
Caught hold of God and saved his soul from Hell.

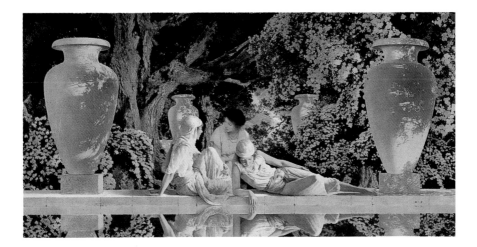

Garden of Allah, 1918

When I'm Gone to Come No Mo'

GEORGIA SEA ISLANDS SLAVE SONG

COLLECTED BY LYDIA AUSTIN PARRISH (1872–1953)

Eatin' of the bread-bread-bread
Eatin' of the bread—O yes my Lord.
I oughta bin to Heaven ten thousand years
Drinkin' of the wine.

(repeat chorus)

If my mother ask for me
Tell her Death done summon' me.
I oughta bin to Heaven ten thousand years
Drinkin' of the wine.

(repeat chorus)

If y'u get there before I do
Tell my Lord I'm comin' too.
I oughta bin to Heaven ten thousand years
Drinkin' of the wine.

(repeat chorus)

Ain' but one thing I done wrong
Stayin' in the wilderness mos' too long.
I oughta bin to Heaven ten thousand years
Drinkin' of the wine.

(repeat chorus)

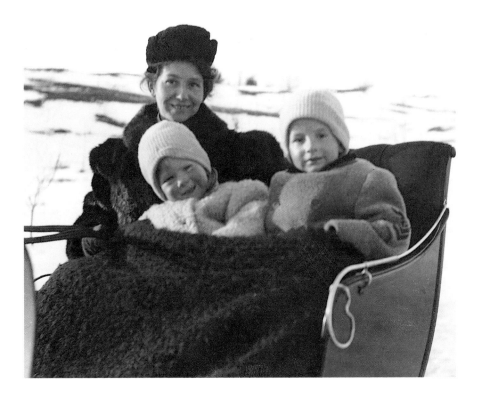

Lydia Parrish with sons Max Jr. (left), age two,
and Dillwyn (right), age four, at "The Oaks," c. 1908
Photograph by Maxfield Parrish, courtesy Dartmouth College,
Baker Library, Maxfield Parrish Special Collection

Trees

JOYCE KILMER (1886–1918)

I think that I shall never see
A poem lovely as a tree.

A tree whose hungry mouth is prest
Against the earth's sweet flowing breast;

A tree that looks at God all day,
And lifts her leafy arms to pray;

A tree that may in Summer wear
A nest of robins in her hair;

Upon whose bosom snow has lain;
Who intimately lives with rain.

Poems are made by fools like me,
But only God can make a tree.

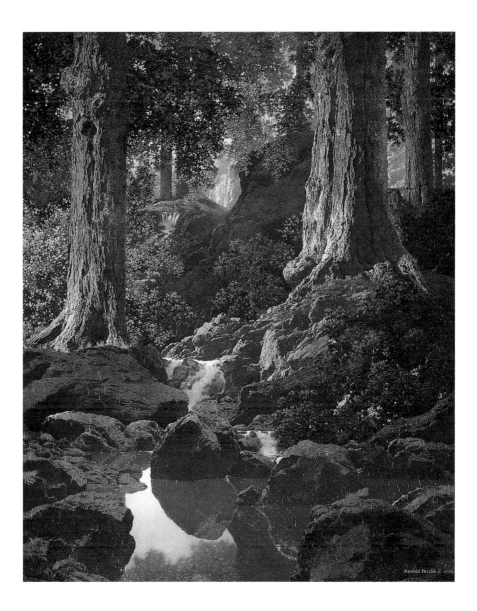

The Glen, 1936